HOW TO
FANTASY FIGURES

Easy-to-follow, step-by-step instructions
for drawing 15 different incredible creatures

MARTY NOBLE

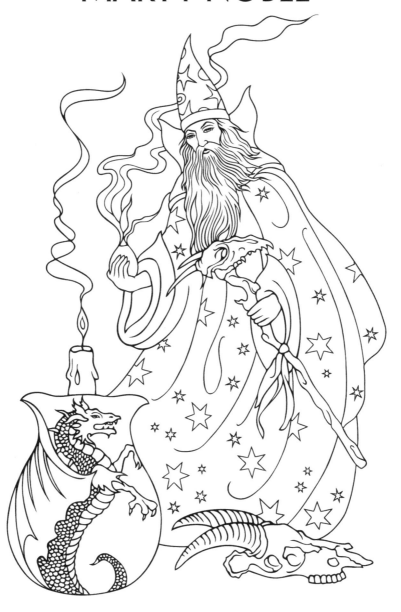

DOVER PUBLICATIONS, INC.
MINEOLA, NEW YORK

Bibliographical Note

How to Draw Fantasy Figures: Easy-to-follow, step-by-step instructions for drawing 15 different incredible creatures, is a new work, first published by Dover Publications, Inc., in 2016.

International Standard Book Number

ISBN-13: 978-0-486-79874-5
ISBN-10: 0-486-79874-7

Manufactured in the United States by RR Donnelley
79874701 2016
www.doverpublications.com

HOW TO USE THIS BOOK

Fantasy has always been a popular subject among illustrators and artists and a favorite theme and inspiration throughout history. One of the joys of drawing fantasy is the sky is the limit creatively. Creating Fantasy is about recreating the world in a way that is relatable, but not of this world at the same time. Each of the characters here have been represented in stories and mythology over the centuries. The Female Warrior has been the most recent to emerge.

All of the characters in this book will be familiar archetypes. The drawings in this book lean toward realism, so the general guidelines for drawing a horse can be used for drawing the Unicorn and the Centaur, who is half-horse and half-human. The Mermaid, of course, is half-woman and half-fish so has her own unique form. Aside from the Dragon and the Werewolf, most characters in this book have a human-type form, whether very large as the Giant, or very small, as the Elf, Fairy, and Goblin. The latter three have slender delicate forms while the Giant is thick and burly. It is helpful to have some understanding of human anatomy before drawing the characters with human traits. Take some time to study the full-page drawing and notice the basic shapes that make up all of the characters. While going from step to step, refer back to the full-page drawing as you develop your character.

The first lines you will draw are guidelines which will be erased in your final drawing. They serve as the foundation on which to build your drawing. Lightly draw in the larger areas of the figures as shown in the first step. Keep your pencil lines on the light side as you develop your drawing so that erasing is easy. After the final step, you can shade your drawing with pencil or graphite or color it in with colored pencils or watercolors. Experiment with soft and harder lead pencils to find what suits your taste.

CENTAUR

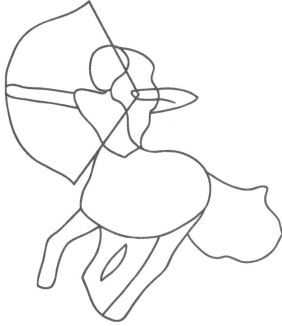

1. Draw a small oval and a wavy shape for the head and hair and a third shape indicating the upper body. Add slender shapes for her arms. Draw an outline for the bow which extends into the upper body of the Centaur. Below the waist, draw the main body of the horse-like character, adding shapes for the legs and tail.

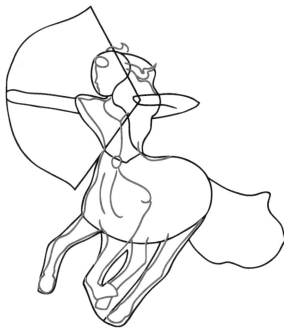

2. Define the profile of the face and add a few lines in the hair area and a small oval for her goggles. Add a few lines within the bodice shape, including the neckline. Take some time refining the horse-like legs and hooves.

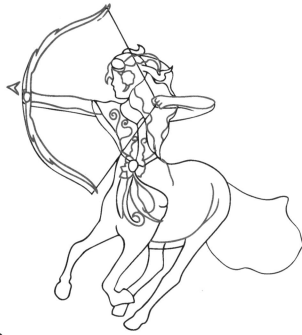

3. Add some detail to the bodice and some decorative elements below her waist, the area that separates the human from the animal. Develop the shape of the bow, adding a small arrow, and draw the arms and hands with more accuracy. Add a bit more detail in the head area and make some rounded lines in the belly area.

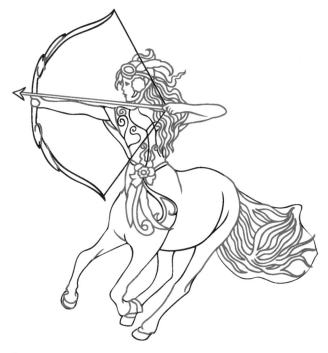

4. Draw the outline of the bow and spend some time drawing lines within the hair. Add some detail to her headdress, which includes a small helmet shape, goggles, feather, and other elements. Add a bit more detail to the waist, legs, and hooves. Take a bit of time on the lines in the tail, as it is a dynamic part of your drawing.

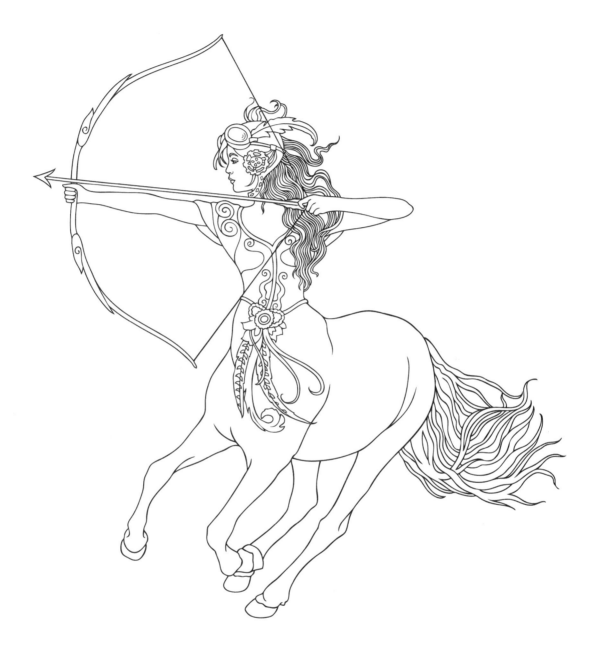

5. Finish your centaur with some additional detail as shown in the full-page drawing. Pay special attention to the angle of the upper body and how it meets the lower body. Take time with the little details and special areas of interest.

DRAGON

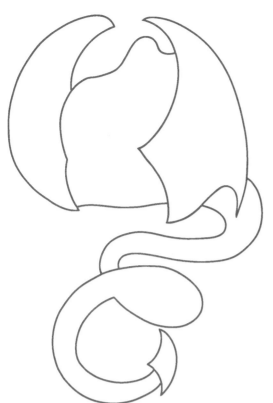

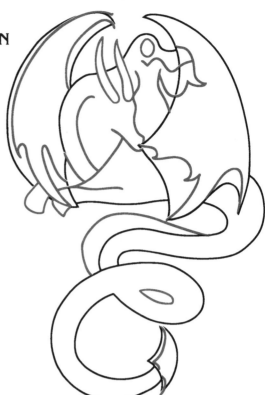

1. Draw an irregular shape on the upper half of the page for the two figures. The shapes on either side of this are the dragon's wings. Draw the curving outline of the dragon tail. The lower part overlaps the upper part. The shape on the end of the tail is the caudal spade.

2. Outline the dragon's right wing and the lower part of the wings with scalloped edges. Add some shapes to indicate the dragon's head, horns, and feet. Draw a small oval for the woman's face and some lines showing the upper area of her gown and hair. Add a few lines to the tail area.

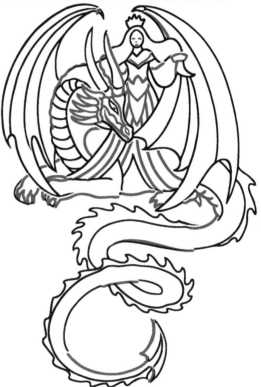

3. Draw a little crown on her head and a few lines to her bodice and lower gown area. Give the dragon a slanted eye and draw a number of curved lines that extend from the upper neck and disappear under the belly. Draw several long curving lines within each wing. Starting behind the left wing, draw an extended scalloped line which will disappear and reappear at the end of the tail.

4. Define the outline of the dragon's legs and feet. Take some time on the dragon's head area with some interesting lines specific to the dragon's face. Five horns extend out from his right jaw. Draw a few more lines in the bodice area and in her lower gown, indicating folds. The finished wings should have a bat-like appearance.

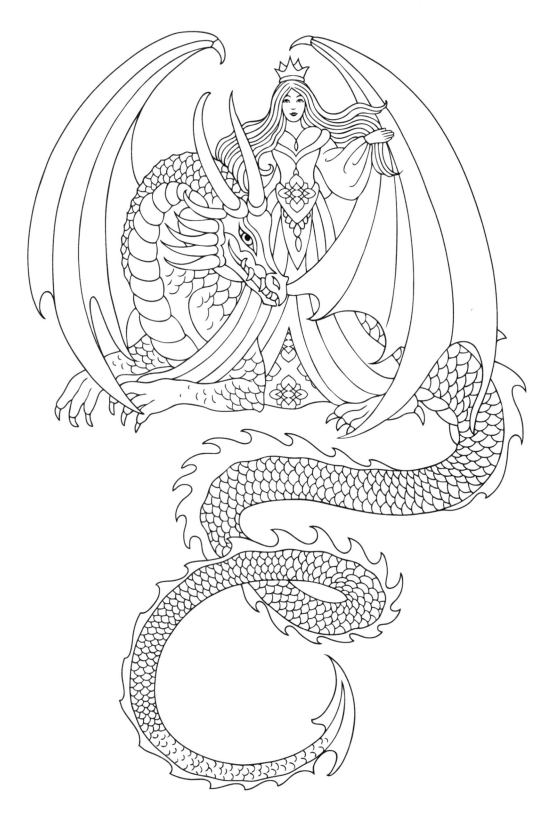

5. Draw the details of her face and take time to draw the wavy lines of her hair. Add decorative details to her gown. Draw the dragon's teeth, details of the eye, and small horns on the wing tops. Study the shapes and angle of the scales along the dragon's body and tail. Scales in nature are symmetrical and overlapping, as seen on a number of creatures, i.e., fish and reptiles.

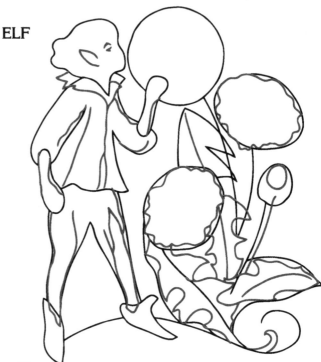

1. Start with several circular shapes to place the blooms. Outline the elf starting with his head just to the left of the top circle. Draw the general shape of his jacket with arms extending out. Draw an outline for his lower body and feet. Add a curving line suggesting a slight hill, curving up on the right .The stems and leaves will look fairly unrecognizable at this stage. Go ahead and draw the extra lines you see below the blooms.

2. Draw a pointed ear, an eye, and eyebrow. His clothing will have a plant-like look. Draw some lines in the area of the collar and jacket and a bit more definition to the arms and hands. Begin shaping his lower outfit and define the shape of his legs. Draw a curvy outline within the two lower blooms. Take some time with the irregular shaped leaves and you will see a dandelion plant emerge.

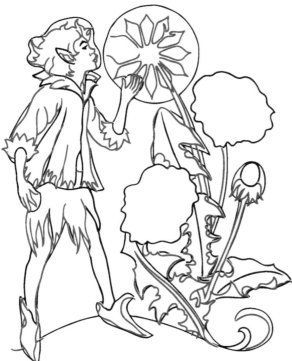

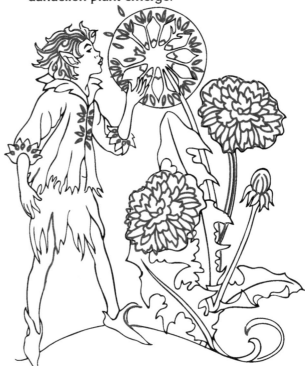

3. Draw the elf's profile, the unruly outline of his hair, and some details in the ear and collar area. Draw the pointed shapes at the sleeve ends, and a refined outline on the sleeves and lower jacket. Draw the slender fingers of the hands and draw the shapes you see in the top circle. Add some more outline detail to the leaves, stems, and flower bud.

4. Draw wavy lines within the hair and add the small details of his jacket. Take some time to add definition to all three flower shapes. The top shape is the dandelion at its last stage of blooming, ready to scatter to the wind. The two lower shapes are in the flower stage with lots of small petals. Add the other small details you see in this step.

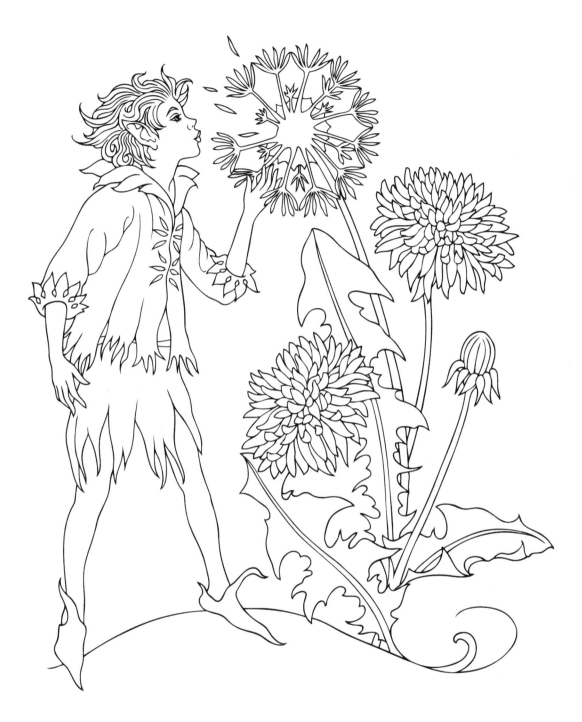

5. At this stage you will be refining and finishing the small lines of the figure and the plant. Focus on different areas of the drawing and fine-tune the details. The eye will be drawn to the Elf's head at first glance.

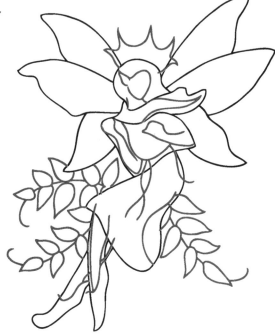

FAIRY

1. Carefully outline the shapes in this step as they will closely follow the finished shape of the fairy. Start with the rounded shape of the head. The two odd shapes below will encase her arms and bodice. Below that draw the outline of her skirt and her legs extending from there. Draw the outline of each three-part wing. These will have a strong showing in your finished drawing so make them a good size.

2. Outline her face and elfin ear. Add a crown shape to her head. Draw another shape within the collar area. Outline her arms and the shape of her bodice with a few ribbon lines trailing down from her waist. Add a curving line within the skirt to emphasize she is seated. Draw some new lines to define her legs and footwear. Draw the outlines of the small leafy stems she is sitting on.

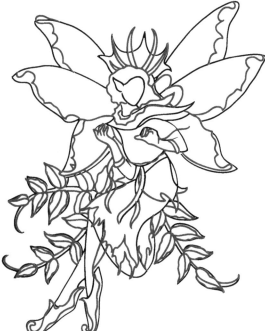

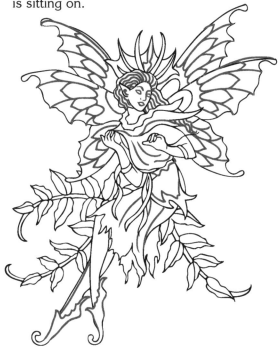

3. Add new outlines to the outer edges of the wings. Draw some curving lines extending up and out of her crown. Draw a wavy outline for her hair and add some more wing-like touches to the collar and sleeve area. Draw her hands and fingers, which will be holding a flute of sorts. Add a bracelet to each arm. Draw a ragged outline along the hem of her skirt. Add some additional detail below her waist, extending the bodice to become a tunic. Draw her fairy slippers and finish the ribbons. Add veins to the leaves.

4. Add a few more lines to her clothing and finish her slippers. Study her legs to see if the outlines are accurate. Draw the details of her face and hair. Add another element to the crown. The rest of this step will be drawing the details of her wings. The patterning in the wings closely resembles that of some butterflies.

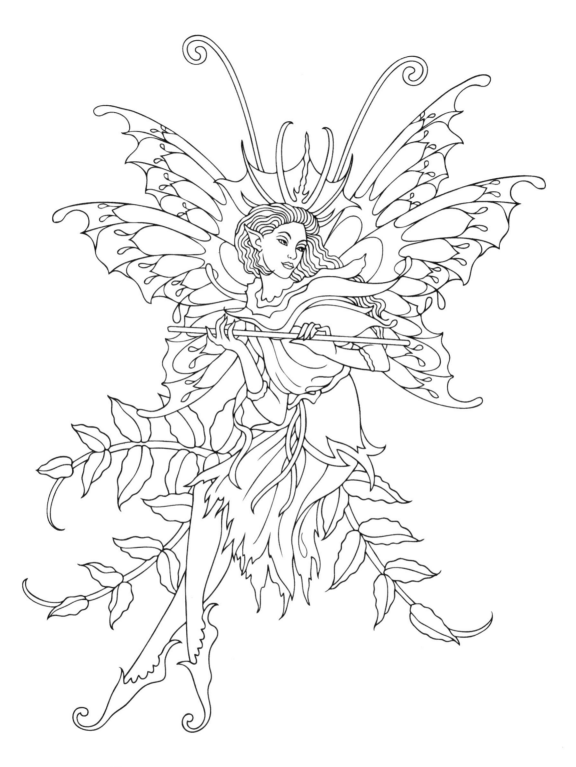

5. Draw two antennae-like extensions coming up from behind her crown. Add the smaller details in the wings. Have a ruler handy and draw the flute shape she is holding. Fine-tune her face, hair, clothing, and slippers.

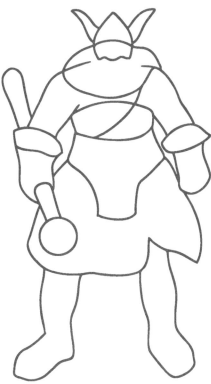

1. Start with the shapes in the head area. Draw the cone outline with the two horns extending. Below that, outline the area for the beard. Then draw the shoulders and arms with their glove shapes for hands. Outline the short torso, adding two lines that cross over the torso. Draw the remaining outlines of his attire and add outlines for his feet and legs.

2. Draw his facial features along with wavy beard. Define the shape of the arms and legs. Outline the hands in their semi-closed position. Finish outlining the belt shapes that cross his torso. Draw the protruding shapes attached to the ball of the weapon. Add some additional lines within his attire.

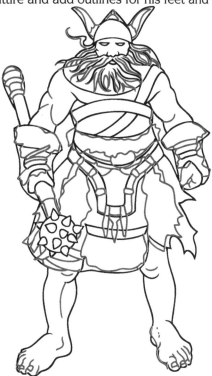

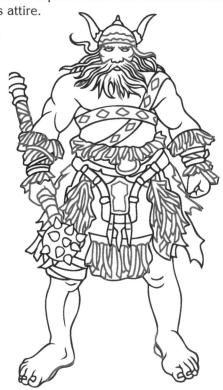

3. Finish drawing the lines of his beard and areas in his helmet along with additional lines on the handle of the weapon. Add more outlines within his lower attire to separate one part from another. Refer back to the finished drawing to make sense of his complex attire and arm ornamentation. Finish his feet and toes and add some shapes for his knees and legs. Draw a few lines to suggest strength and muscle in his upper body.

4. Add diamond shapes to the "belts" crossing his torso. Finish his right hand and the details on the handle of his weapon. All the shapes around his waist, arms, and other areas of his attire appear to be various lengths of leather, longer lengths wrapping around his wrists. Take your time drawing these details. They add character to the look of the Giant.

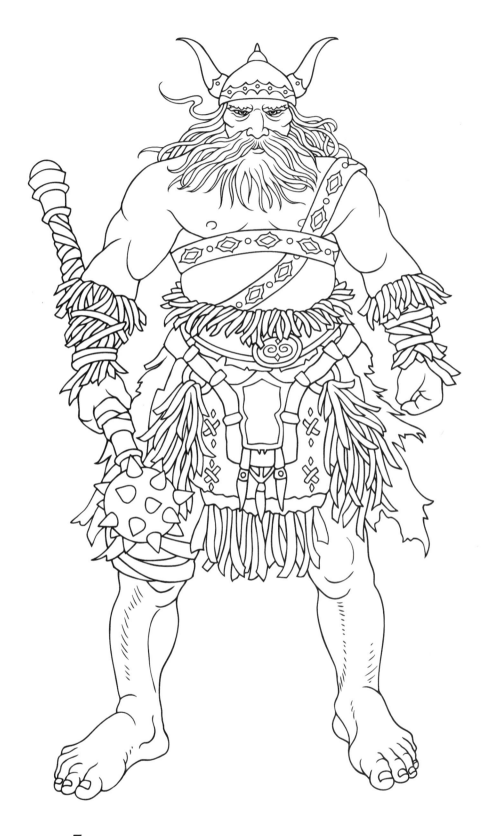

5. Add any additional detail needed to his overall attire. Take some time defining his beard and face, especially around his eyes and brows. Add some fine lines to suggest shading within his legs and a bit more detail on his feet.

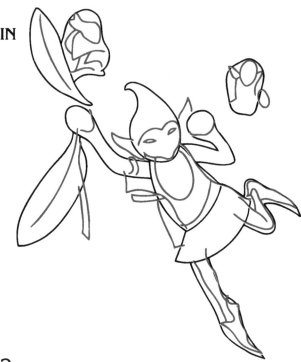

GOBLIN

1. Draw the various shapes that make up the Goblin, noting the diagonal angle of his body. At this stage he is somewhat recognizable with arms, a head, small body, and legs. Draw three shapes coming from his outstretched right hand and another small shape on the other side. Refer to the full-page drawing to see what these shapes will become.

2. Draw lines to define the shape of the faces. Draw two curving lines down the center of each feather. Outline what will become two very small goblin-like creatures. Draw a branch connecting the two feathers. Outline the shape of the legs and pointed shoes. Add some lines to indicate a scooping neckline, upper arm bracelet, and shape of upper body.

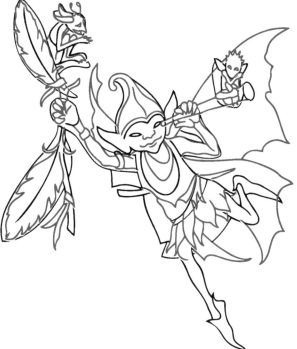

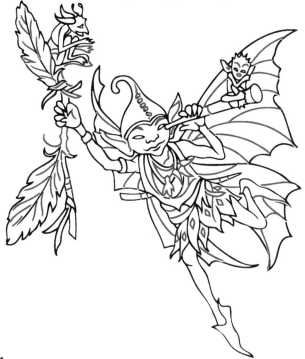

3. Draw the outline of the feathers and additional detail on the small creatures. Define the arms, narrow and muscular, and the hands, both in a grasping position. Add some ties to the branch, one holding the top feather and the other on the bottom. Outline the wings and draw a few more scooping lines for his necklaces. Draw the lower part of his costume, noting the overlapping leaf-like shapes. Add the nose and mouth, the straight lines of the spyglass, and outline the shape of his hat.

4. Add some definition to the feathers and a bit more detail to the small characters. Draw the lines in the wings and add some ornamentation to the clothing and necklaces. Outline the brows, the detail in the ears, and hat. Define the branch he is holding below the right hand.

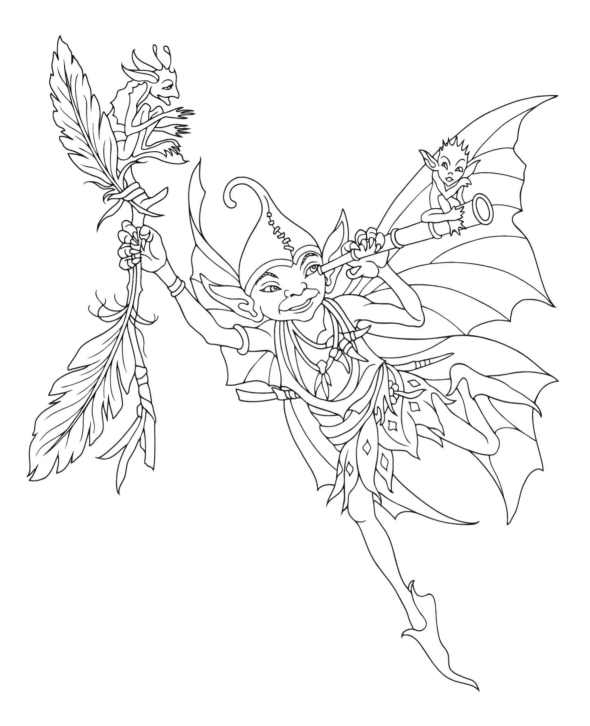

5. Draw the detail of the eyes, brows, and other areas of the face. Define his claw-like fingernails and other small lines within the hands and add a small bracelet to the right wrist. Finish the spyglass with its four sections and any other areas that need a bit more detail.

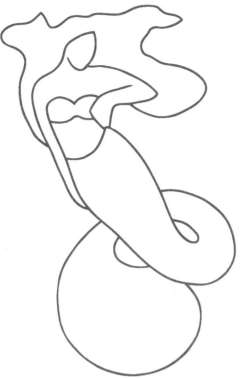

MERMAID

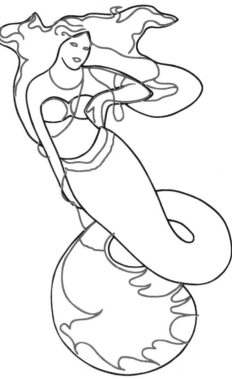

1. Draw an outline for the flowing hair of the mermaid and within that space another outline to encompass her arms, head, and the shape of her clamshell top. Make a curved line to separate the upper and lower body. Draw another rounded outline of her fish-like lower body, paying attention to how the tail overlaps itself.

2. Draw her eyes and mouth and several wavy lines that cross over her upper body and down to her right hand, including a curved line below her neck. These will become a necklace and strings of pearls. Draw two more curved lines below her waist. Define her left arm. Outline the sculpted shape of her tail fin. Add some detail to her hair.

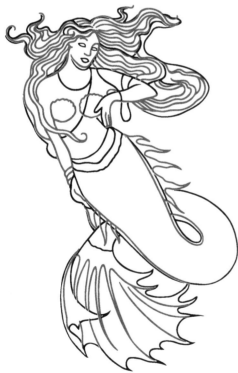

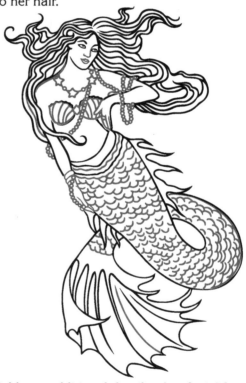

3. Carefully draw the wavy lines of her hair. Spend some time on this step. There is a bit of ear showing as you define the outline of her face and neck. Define her arms and draw her left hand and the small space for her underarm. Draw 2 bracelets on her right hand and outline the clamshell top. Add some veins to the tail fin and smaller fins along the sides below her waist.

4. Add any additional detail to her facial features. Draw the clamshell ribs. Add three star shapes to her necklace and three tiny pearls. Draw rounded pearls all along the lines you have created for this, noting where the lines disappear behind her arms. The last detail will be the scales which overlap and cover her tail. You can fine-tune these in the final step.

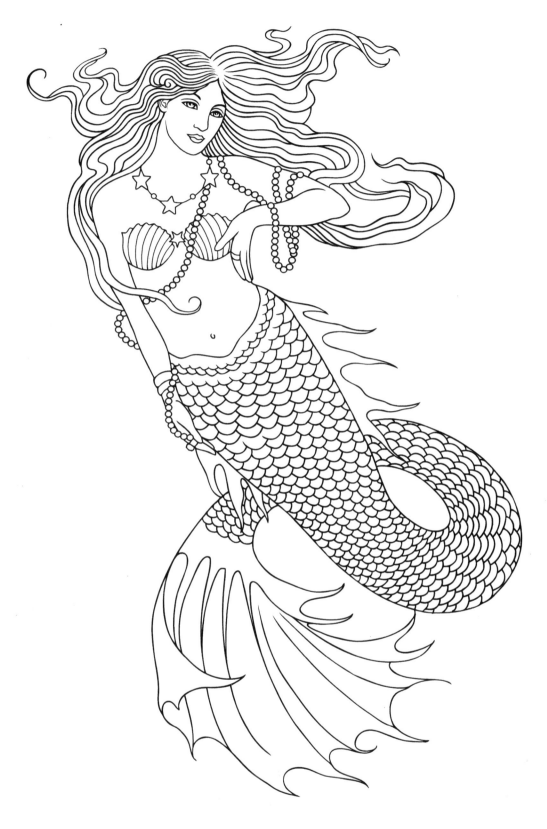

5. Look back over you drawing to see what finishing details need to be done. Scales can be portrayed in a variety of ways. Feel free to study other illustrations or examples for ideas on drawing scales. It may be helpful to examine the scales of a fish as they appear in very consistent patterns along the body.

SORCERER

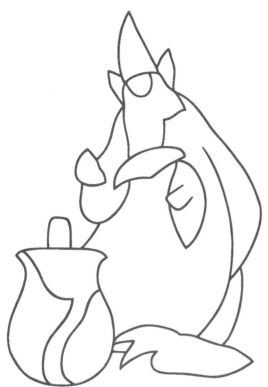

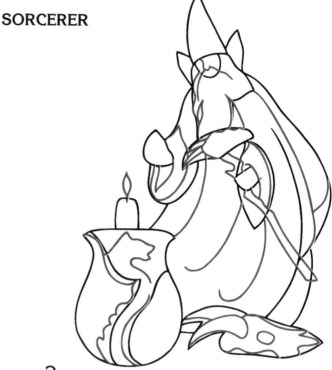

1. Draw the cone shape of the sorcerer's hat, the outline of his face, beard, and the collars of his cape. Outline his robe and the shape for an animal skull. Outline the vessel and draw a candle. Add two lines inside for the beginnings of a dragon. Draw the shape of his right sleeve and a smaller shape on top of that. Draw another shape overlapping the bottom of his beard and another shape just below.

2. Draw the line of the nose, a few lines in the beard, and the fold lines of the robe. Define the shape of both skulls with their horns and an eye socket. Draw the stick that holds the upper skul, the large cuffs of each sleeve, and the flame on the candle. Draw the shapes within the vessel that will start to define the dragon.

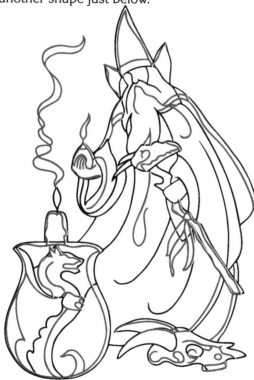

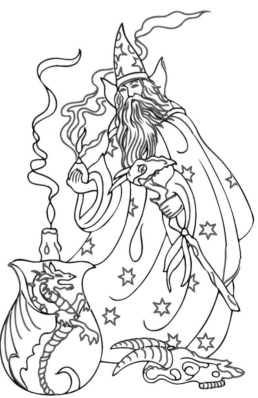

3. Add some more detail to the dragon, a new outline for the candle, and draw lines for smoke. Draw his right hand holding a small cone-shaped candle with a flame. Refine the shape of his hat, collar and robe. Draw a few lines in his beard and a few ribbon-like ties on the stick. Add more detail to the skulls.

4. Draw the smoke that trails behind the sorcerer and the stars and shapes you see on his hat. Draw the lines of his beard, the details of his face, several stars on his robe, and a bit more detail to the stick and the skull. Finish the detail of the lower skull, and the dragon, minus the scales, and add a bit of detail to the candle above.

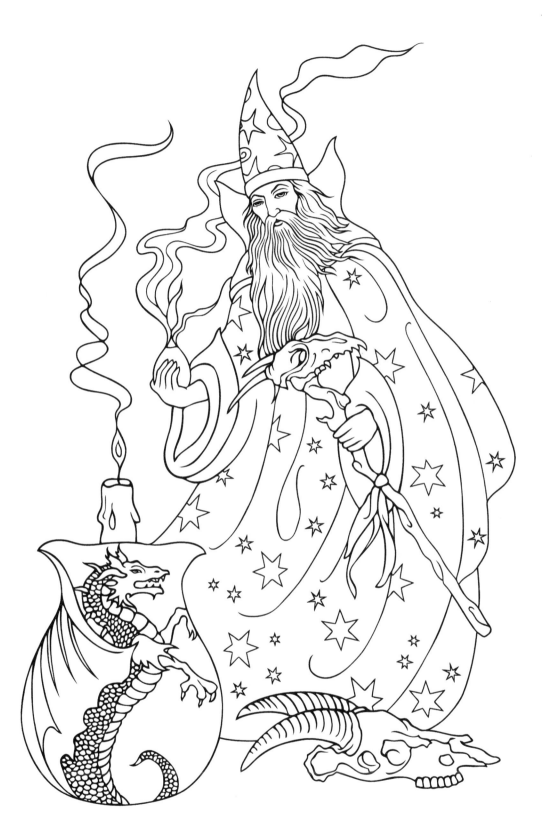

5. Draw scales on the dragon, some smaller stars to the
robe, and any other detail not yet added to the overall
drawing, especially the face and beard. Note the rough
and interesting appearance of both skulls.

SORCERESS

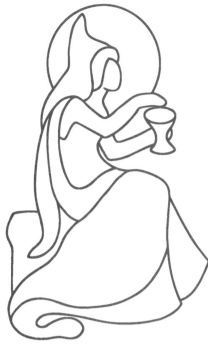

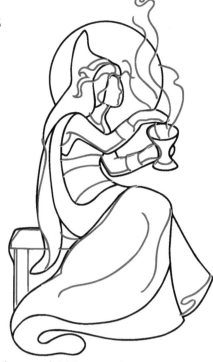

1. Draw an outline for the cape and gown of the sorceress. Study her form to determine how the different parts connect. Outline her arms and upper body, adding lines for her hairline and face and neck as it curves down to meet the right arm. Between her hands draw a simple goblet. Draw a circle behind her. Add the shape of the bench she is sitting on.

2. Add some fold lines to her cape and gown to emphasize the way it drapes. Refine the shape of her arms and add the bracelets. Draw a few curving lines of hair trailing into the hood of her cape and several lines coming up out of the goblet. Outline the bench she is sitting on.

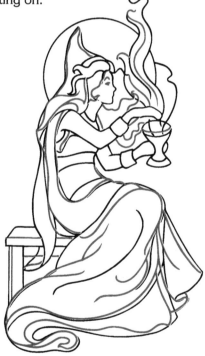

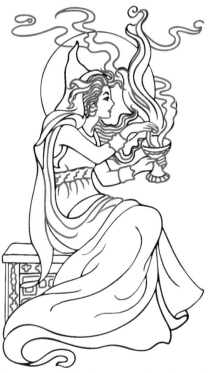

3. Refine the different areas of her cape and gown including the outlines. Add several more fold lines here and there and note the curvy flow of the hem. Draw two horizontal lines on the bench. Add more lines coming up from the goblet and draw some additional lines behind her arms to indicate long wavy hair. Outline the hair on her face and add an eye and eyebrow.

4. Add the rest of the lines coming from the goblet, waving and curling here and there over and behind the circle. Add some detail to the goblet and to both of her hands. Define the shape of the bracelets. Take some time to complete the lines of her hair. Fine-tune her mouth and chin. Add the detail to her waistband and small fold lines right below. Add decorative elements to the bench. Refine the outlines of the bracelets.

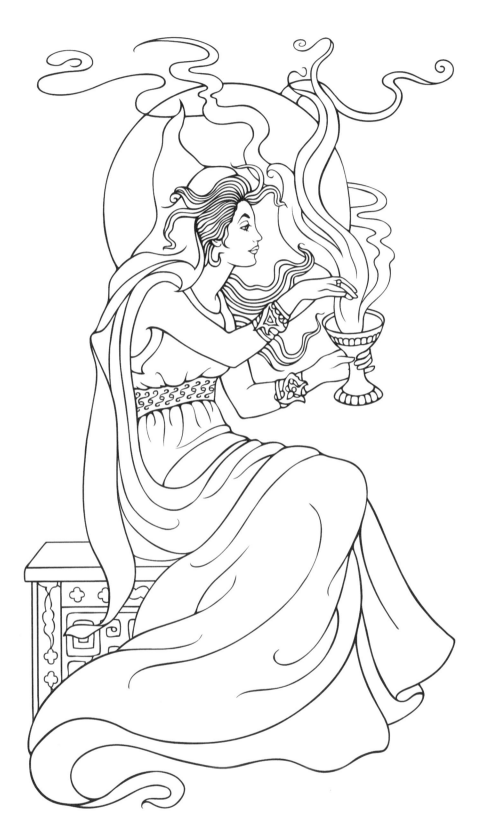

5. Add the interior detail of the bracelets and finish the goblet. You may want to add additional detail to her face and hair. Draw a few additional fold lines around her waistband and add a ring to her right finger.

UNICORN

1. Start your unicorn by outlining the basic shape of the horn (also known as an alicorn), head, and area for the mane. Below that draw the rounded body, the outer shape of the tail, and the area for the legs. The small shape within the leg area will form the separation of front and back legs.

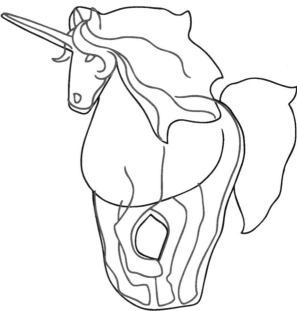

2. Narrow the outline of the horn, draw the ears with a few strings of mane coming from between the ears and flowing toward the back of the body. Add an eye and nostril and define the nose and jaw where it meets the mane. Reshape the rump of the unicorn and extend it down drawing the left back leg. Draw the other three legs in the space provided. Continue the lines of the front left leg up into the main body and indicate the hooves as you draw the legs.

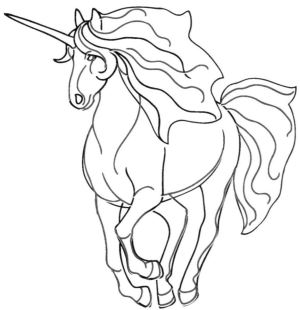

3. Add a few more lines to the mane and several lines to the tail. Work on the shape of the head and add some detail to the face, defining the mouth and chin. Draw a line separating the leg and hooves. Continue fine-tuning the shape of the legs.

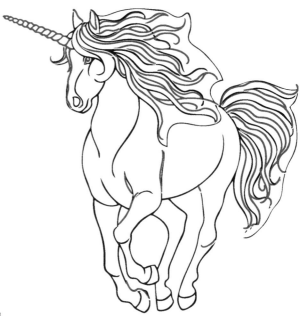

4. Draw the ribbed pattern along the horn with its irregular outline. Refine the ears and a few details on the legs. Take time on the mane and tail, as these contribute to the flowing and magical appeal of the unicorn.

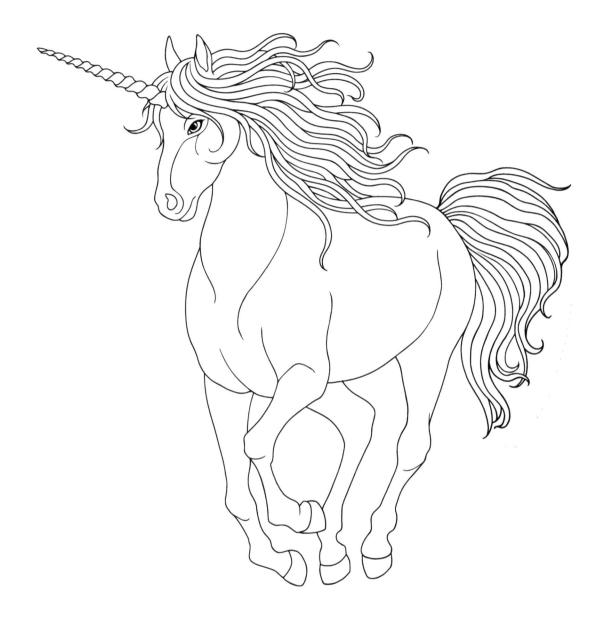

5. Add the rest of the detail to the eye, if you haven't
done it already. Check your overall drawing for
accuracy, particularly in the body and legs. Horse legs
can be tricky to draw, and when done correctly add
much to the beauty and grace of the animal.

VAMPIRE

1. Start by drawing a small oval for the vampire's face and add two bat shapes below. Outline her garments by studying the different shapes that make up her hood, gown, and cape.

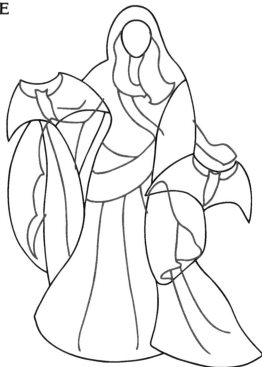

2. Draw the bat bodies and their upper wings, a portion of her right arm, the outline of her hair, and two diagonal lines under that. Draw a curved line right below the waist area. Add another two lines at a diagonal. Add some fold lines and a curving hemline. Under the upper bat draw a scalloped line.

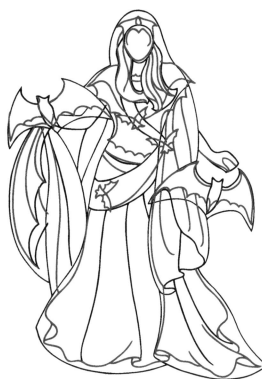

3. Redraw the outline of her lower gown, paying special attention to the folds in the hem. Draw the scalloped edges of the bat wings and add a few lines to their bodies. Between these two add three smaller bats. **Add several lines to her hair and a decorative bat shape** above her face. Add a few more lines to the draping part of her clothing. Draw the lines of her **top, with its bat wing style. Outline her left hand.**

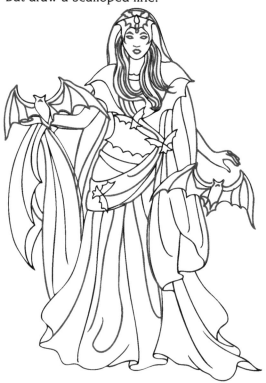

4. Draw the features of her face and refine the shape of her hood. Draw the separations in the bat wings, new details on their bodies, and a mouth for each. Finish her arms and hands and the lines in her hair. Add the rest of the lines you see in the drapery.

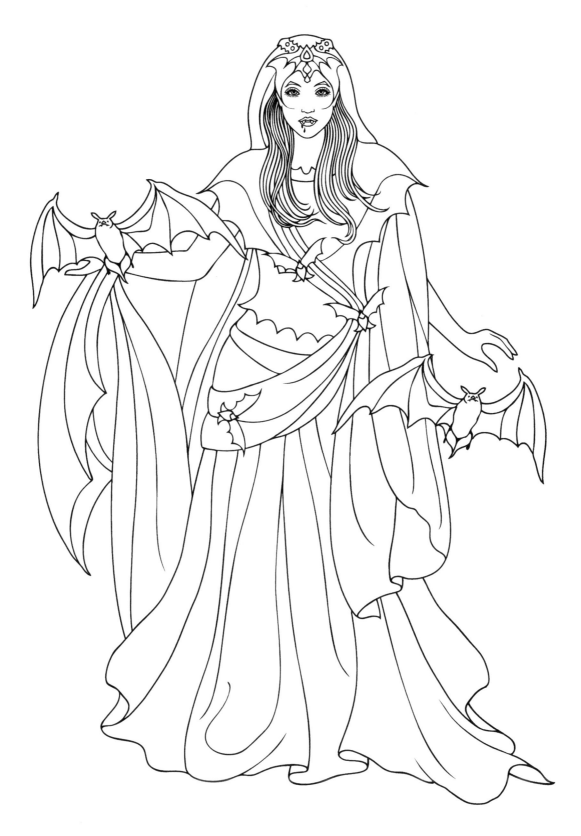

5. Draw the remaining detail of her hood ornament.
Take some time with her face to give her that
"vampire expression." Finish the larger bats with
their small facial features and their alert-looking
ears. Look to see if there are any remaining areas to
be finished.

WARRIOR FEMALE

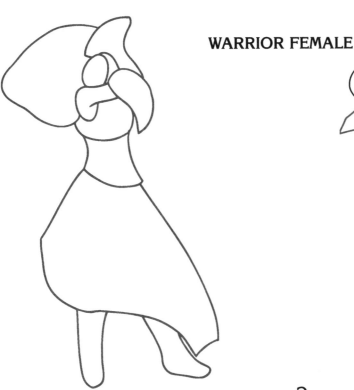

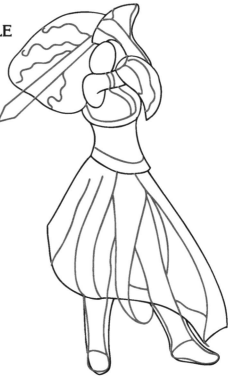

1. Draw a small tipped oval, the outline of her right arm, and her shoulder up across her chin. Draw a large tear shape at her elbow, a mushroom shape angling back toward her head, and the outline of her "big hair." Below this draw the outlines of her upper body, skirt, and legs.

2. Draw an outline for her sword, arm, and hands and add a few wavy lines for hair. Add a bracelet to her upper arm and outline the armpiece she is wearing. Draw the lines of her bust and another line in the area of her waist. Outline her legs, boots, and her skirt.

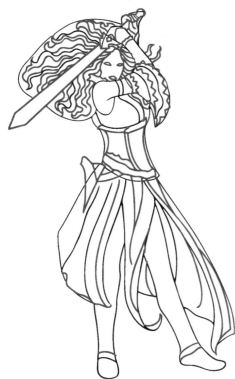

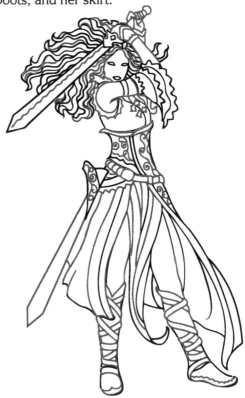

3. Outline her gloved hands in more detail. Draw the wavy lines of her hair and add her eyes and mouth. Outline a small bracelet on her right wrist. Above her right shoulder add a small shape that will be an extension of her collar. Draw some new outlines in the area of her corset. Draw the outline of her belt with its side attachment. Add several lines within the skirt and redefine that outline. Finish the decorative arm piece.

4. Finish her gloved hands and draw the detail of the sword handle. Add the zigzag line down the length of the sword. Draw the scalloped outline of bodice arm opening. Add the decorative clasps on her bust line. Decorate her corset and define the parts of her belt and sword case. Finish the lines of her skirt and draw her boots.

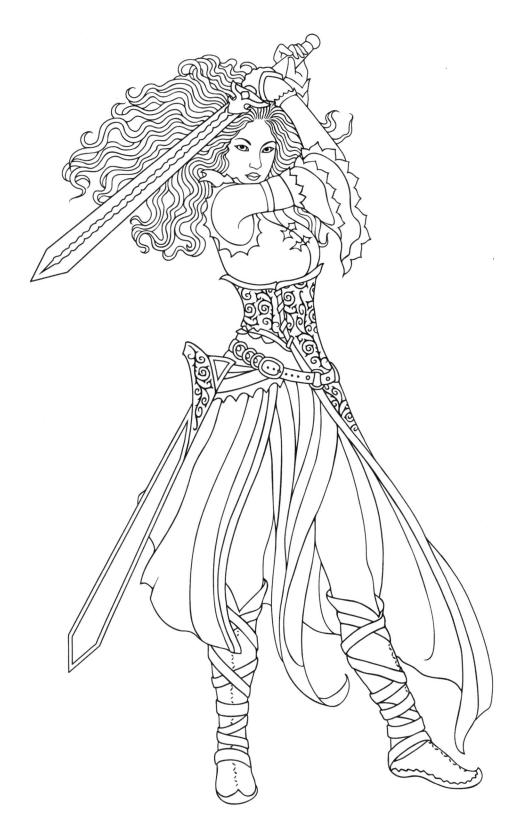

5. Add another zigzag line down the sword and bring to a connected point. Finish the details of her face, belt, and corset and any other areas that need an extra touch. Add some tiny stitches up the center of her boots.

WARRIOR MALE

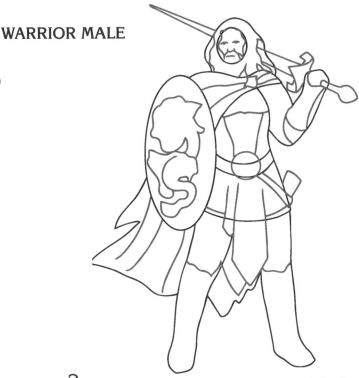

1. Draw an elongated oval for the Warrior's shield and a smaller oval for his face. Draw an outline around his face for his hair. Add the upper cape, his torso with a belt, and his left arm. Outline a portion of both legs and draw an irregular outline for the rest of the cape. Continue the line from his right leg to the left.

2. Draw the shape within the shield and the features of his face with a bit of beard and hair. Add the shape on the shield and several lines to the arm and hand. Draw the outline of the sword, a belt buckle, and the lines that make up the scabbard. Add the fold lines of his cape. Draw the top of the boots and the outlines below his belt.

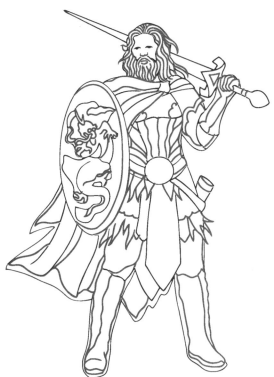

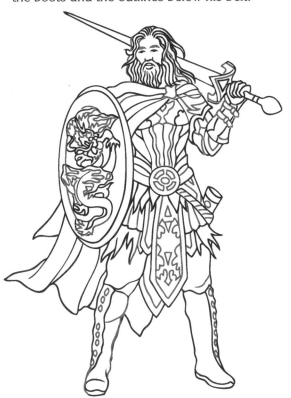

3. Draw the lines of his hair, beard, and the fingers of his hand. Add more lines to the arm gauntlet and a small triangle shape to the sword handle. Draw a number of lines in the area above his belt and his sleeve. Draw the overlapping triangle shapes below his belt. Redraw the boot outlines and the pants. Draw a new outline for his cape. Add an inner oval shape to the shield and some features to the dragon.

4. Add eyebrows and a few more lines to his hair. Finish the detail in the sword handle and add straps to the arm gauntlet. Refine the shape of the cape clasp and finish the decorative work on his garments. Add small round shapes to his boots. Continue working on the dragon.

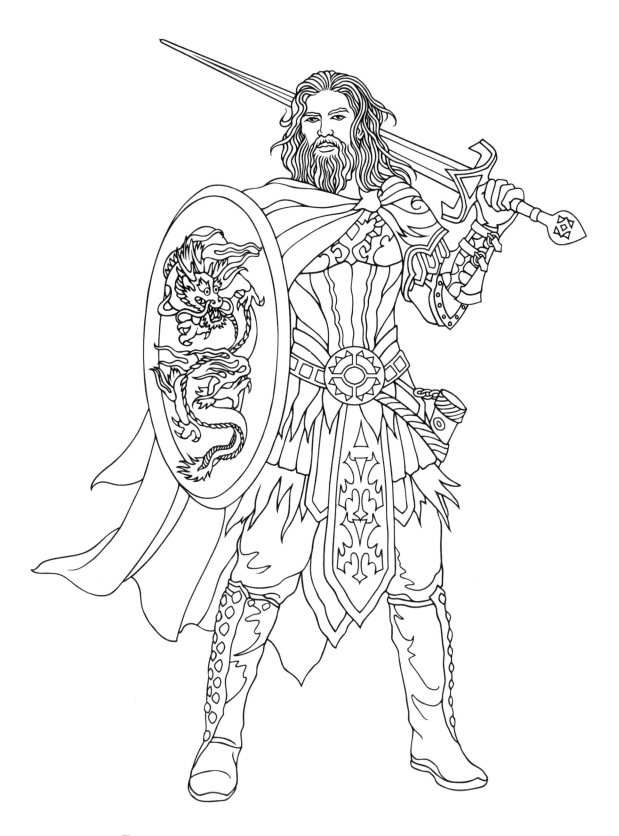

5. Add any little details that are needed, including the design on the pommel, the extra detail on the belt and buckle, the short chain, and the small parts of the arm gauntlet. Finish the dragon and add a few lines in the boots and pants to suggest folds. Add any detail that is still needed in the face. Draw the thin line inside the sword.

WEREWOLF

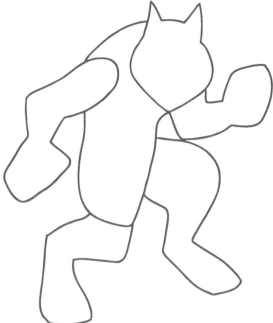

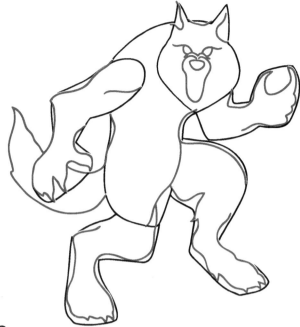

1. Start with the rounded shape of the werewolf's head, giving him pointed ears and and a pointed chin. Draw the arc of his back curving up to meet the right ear. Draw outlines for his arms with their large paws. Continue the shape of the body from under the arm back up to the point of the chin. Outline his legs and large "foot" paws, noting the difference in size and shape.

2. Draw new outlines within the shapes to make his arms, legs, body, paws, and feet more distinct. Outline his tail and draw the openings for his ears and an indentation at the top of his head. Outline his muzzle, nose, and eyes.

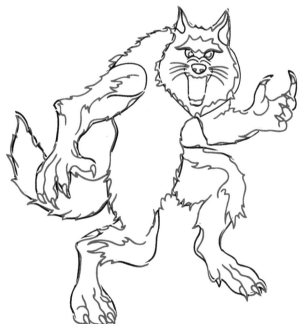

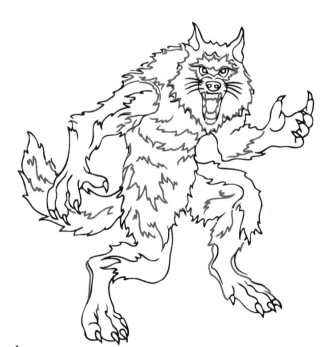

3. Add details to the eyes and nose. Draw his whiskers and the opening of the mouth. Define the paws of his hands and feet and draw the pointed and distinctive claws. Draw the outline of the whole body again, creating the jagged texture of his fur. Add more fur lines to both legs and one arm.

4. Draw additional overlapping fur lines all over the body. These will indicate the length of the fur and his tousled look. Draw his teeth and outline where the tongue lies. Add a few fur lines in the area of his brow and around his head.

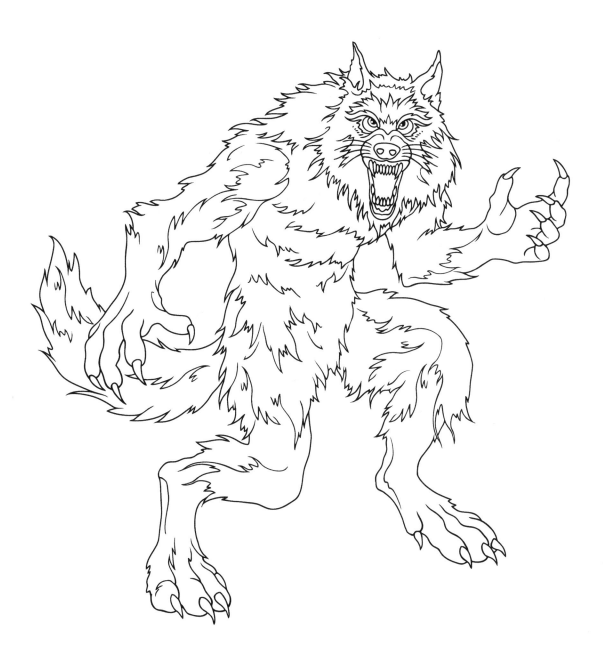

5. Add some additional fur detail to his head and any
other areas that need it. Draw the smaller details of the
face and head, particularly around the eyes.

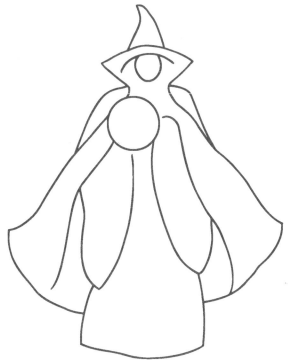

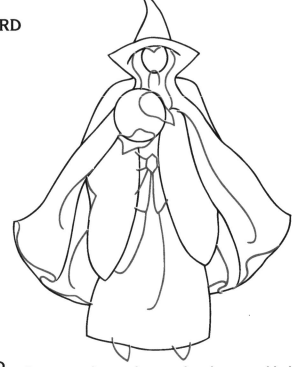

1. Begin by drawing the circle for the Wizard's crystal ball. Above and to the right draw a partial oval and above that an arc for the opening in his hood. It will look like a big eye. Outline his hood and cape and within that area draw the outline of his robe, including the very large sleeves.

2. Draw two shapes that overlap the crystal ball where his hands will be. Draw a widow's peak on the hood brim and outline his beard. Draw the curving folds of the cape's hem and a few extra lines to suggest folds. Draw the lines in the area of the belt and the hexagonal shape of a belt buckle. Outline his pointed shoes.

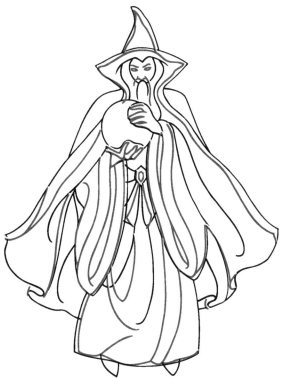

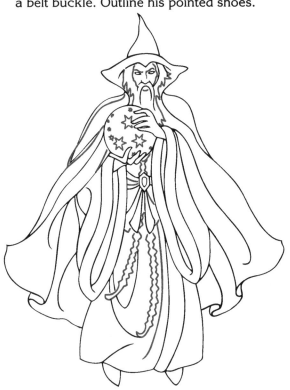

3. Draw his eyes and nose with a bit of beard trailing down. Refine the shape of the hood and the area where the cape opens. Draw the fingers of his hands and the long curving sleeve cuffs. Add the buckle and sash detail and several fold lines in his robe. Refine the line of the hem.

4. Outline the hair and beard as it appears in the large drawing. Check the curve of the right shoulder to see if it needs adjusting. Add stars to the crystal ball, three large and the rest smaller. Draw the design element above the buckle and continue that design along two of the previously drawn lines where they swoop down below the sashes. Draw the curve of his lower lip.

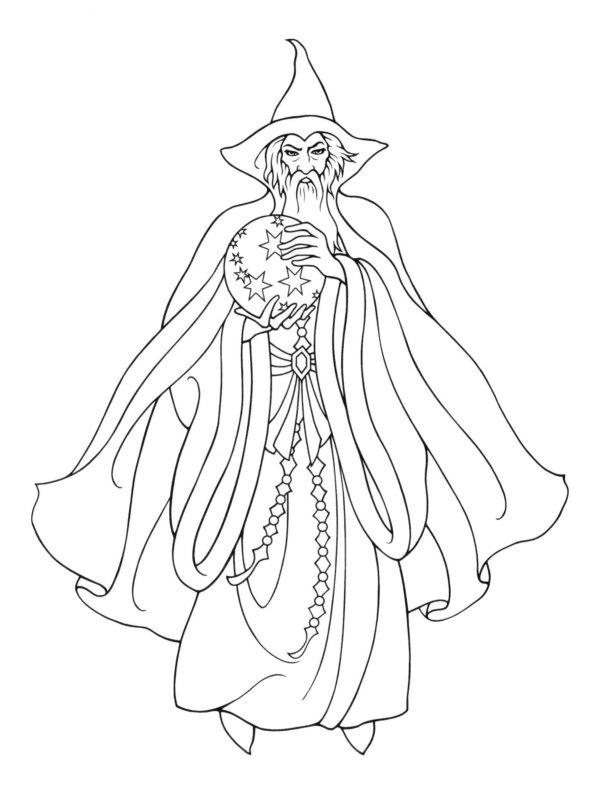

5. Look to see if the eyes need a bit more work. Add the small lines under the eyes and emphasize the arch in the eyebrows. Add a few more lines along the hair and beard close to his face. Study your finished drawing to see if there are any other adjustments to be made.